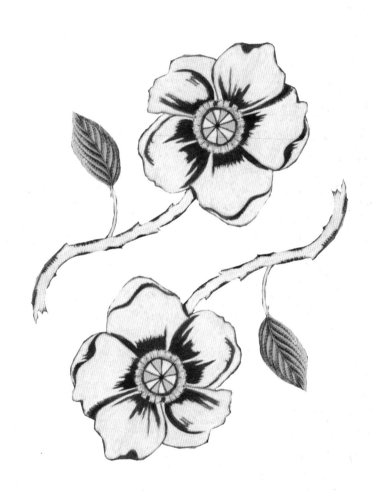

SOMEWHERE
IN
CHICAGO
THERE
IS A
DOG
THAT
REMEMBERS
THE
STARS
AND
MY
DAD

THE WONDER

Portraits of a Remembered City ✶ VOLUME 2

The Dream City

TONY FITZPATRICK

La Luz
de Jesus

Last
Gasp

Drawing Collages
TONY FITZPATRICK | *Chicago, IL*
www.tonyfitzpatrick.com

Design
FIREBELLY DESIGN | *Chicago, IL*
www.firebellydesign.com

Artist Essay
ALEX KOTLOWITZ | *Chicago, IL*

Photography
MICHAEL TROPEA | *Chicago, IL*

Editors
BILL SAVAGE | *Chicago, IL*
JANICE S. GORE, PH.D. | *Los Angeles, CA*

Publishers
LA LUZ DE JESUS PRESS | *Los Angeles, CA*
www.laluzdejesus.com

LAST GASP | *San Francisco, CA*
www.lastgasp.com

Printer
PROLONG PRESS LIMITED | *Hong Kong*

First printing 2006

ISBN 0-86719-655-6

To
Ed Paschke
1939-2004

One of ours.

When I was out there in the Pacific waiting for the Japanese…hoping they wouldn't get me…what I dreamed about was the city…the millions of light-bulbs…the buses and trains…the music of all of it…what I dreamed about was home…at night, in my dreams, I could see Chicago

– James Fitzpatrick

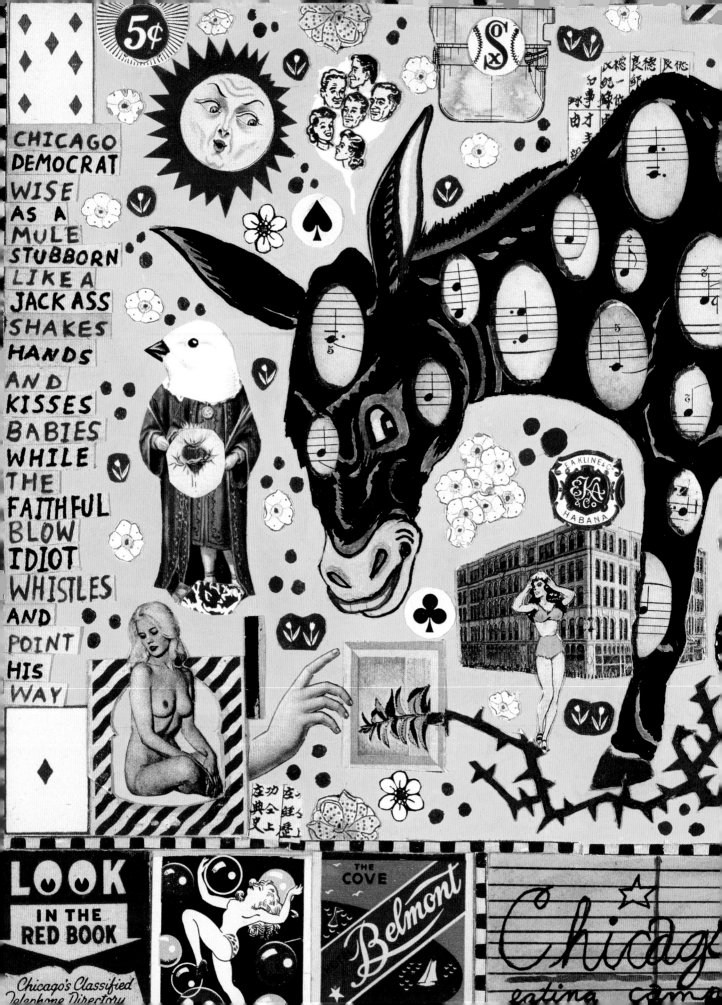

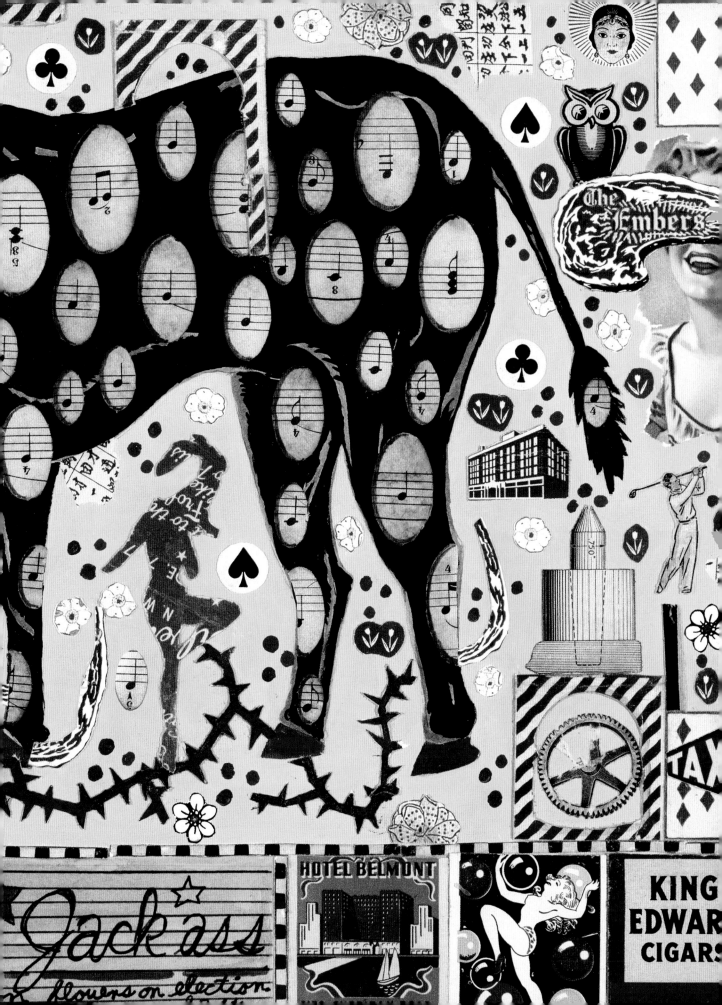

The dead say nothing
And the dead know much
And the dead hold under their tongues
A locked-up story.

– Carl Sandburg
 "The Chicago Poems"

ONE SUMMER NIGHT NOT LONG AGO, TONY AND I

walked the few miles from downtown Chicago to Bucktown, the neighborhood where Tony has his studio. A cool breeze blew off the lake, and so Tony, who was in shorts, had donned a denim jacket. At a brisk pace, we walked past the dilapidated, discolored highrises of Cabrini Green—or at least what's left of them—inhaling the fragrance of marijuana drifting down from the fenced-in galleries above. We then arrived at the Division Street Bridge, which straddles the Chicago River. As we leaned on the iron railing, admiring the city's night lights, a blue heron jetted out from under the bridge, startling us. It flew low and awkwardly, its dangling, pencil-thin legs skimming the water's surface. Our attention, though, was again diverted as a long, phallic speedboat pulled up alongside the shoreline, and a dolled-up couple emerged to dine at a riverside restaurant, which has a bar with a distinctly Caribbean flavor on its upper deck. I took a deep breath, contemplating how it is in one place, at this one time, so much can be going on, and so much that seems so far apart: the manmade and the natural, the comfortable and the afflicted, the graceful and the awkward. In that moment, it was like being let inside one of Tony's drawing collages. Lives and moods and situations colliding. Tony's work marvels at the beauty and destruction of the city; it revels in the city's contradictions. The very art form he chooses—an assemblage of drawings alongside lost and found works of common art (most notably matchbook covers)—reflects the wild juxtapositions of power and fragility in his hometown, Chicago, America's city.

Chicago has a reputation—and a rightful one—for its grittiness, its toughness, its duplicity. Sandburg's description, "the city of big shoulders," has become Chicago's signature. It stays with us, even some 90 years after Sandburg wrote the poem titled simply *Chicago*.

Most can't let go of the notion that this is a blue-collar, hardworking, dirt-under-your-fingernails kind of place. I remember in the ninth inning of the last game of the World Series, when it was clear the Chicago White Sox were about to win their first championship in 88 years (a subject for future works of Tony's; he is, after all, a lifelong, unreconstructed, and until now long-suffering Sox fan), the television announcer began to wax eloquent on Chicago's South Side, this hodge-podge of ethnic groups, many of whom worked, he continued, in the stockyards. In the stockyards? The last of them closed 35 years ago. That old Chicago seems to never die.

But Tony sees the city differently. He sees things the rest of us don't. He knows well the rough-and-tumble Chicago, the Chicago that will take you for all you're worth if you're not watchful, but he also sees a dreamy and exotic place, a city where even he -- a former Golden Glove boxer -- can imagine a curvaceous mermaid emerging from the deep, clear waters of Lake Michigan. (And to think the rest of us thought they existed only in our great oceans.) People have long come to Chicago to stretch, to dream, to be someone else. "It's a place that allows you to run," Tony says.

To enter Tony's drawing collages is to walk into a world both fantastical and genuine. Tony lingers on that narrow ledge that distinguishes the real from the surreal. A chicken wearing a crown. A caterpillar ogling a shapely nude woman. A feral dog. Dark skies so filled with magical and sensual images that it'll make anyone want to stay up late into the night. Angels masquerading as moths. This latter image encapsulates Tony's love for the messiness of this city. There is, after all, such beauty and destructiveness in these insects. It reminds me of what Richard Wright once wrote of Chicago: "There is an open and raw beauty about that city that seems either to kill or endow one with the spirit of life."

Tony sees those paradoxes in the authentic as well as the fantastic, as in his ode to Fred Hampton, the Black Panther who in 1969 was killed by the police as he lay in his bed. It was a tragedy, an outrage. (An FBI investigation found that the Panthers had fired one shot, the police between eighty-three and ninety-nine.) The shooting not only galvanized Black Chicago, it also got others thinking about their

political leaders in a different light. It did that for Tony's dad, who sold burial plots, and until that moment hadn't reason to ask many questions of those in charge. "They murdered that kid," he told an 11-year-old Tony. It's a city of such cruelty and of such vitality.

Yet people keep coming here. Chicago has long been a city of destination, a place to which young men from the farms, young women from small towns, blacks from the south, and immigrants first from Europe, then from Mexico, have been drawn. They could find work here. They could find communities filled with people just like themselves. But there was more. They could curse and drink and love. They could reinvent themselves. And then do it again. Laughs Tony, "It's a journey to get here even when you get here."

Chicago is a city of romance and optimism alongside the failed and the fragile. And that's what you'll find in Tony's boisterous, kaleidoscopic works of art. A yellow canary and barebreasted women alongside a slain high-class prostitute and a murdered black man. Tony once told me he thought of these drawing collages as a kind of diary. But don't take that too literally. It's a diary of his imagination, an imagination whipped up and inspired by his hometown. Tony has said of Chicago, "This place gets in your bones and ruins you for anywhere else." The same might be said of Tony's art. It, too, will get in your bones and ruin you for anything else.

ALEX KOTLOWITZ
December 2005

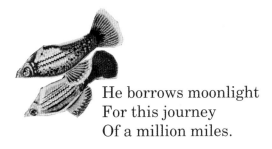

He borrows moonlight
For this journey
Of a million miles.

–Saikaku

Wonder ☆
☆ *Dog* 2004 ┊ 10" x 13"

Collection of Hales Gallery, London

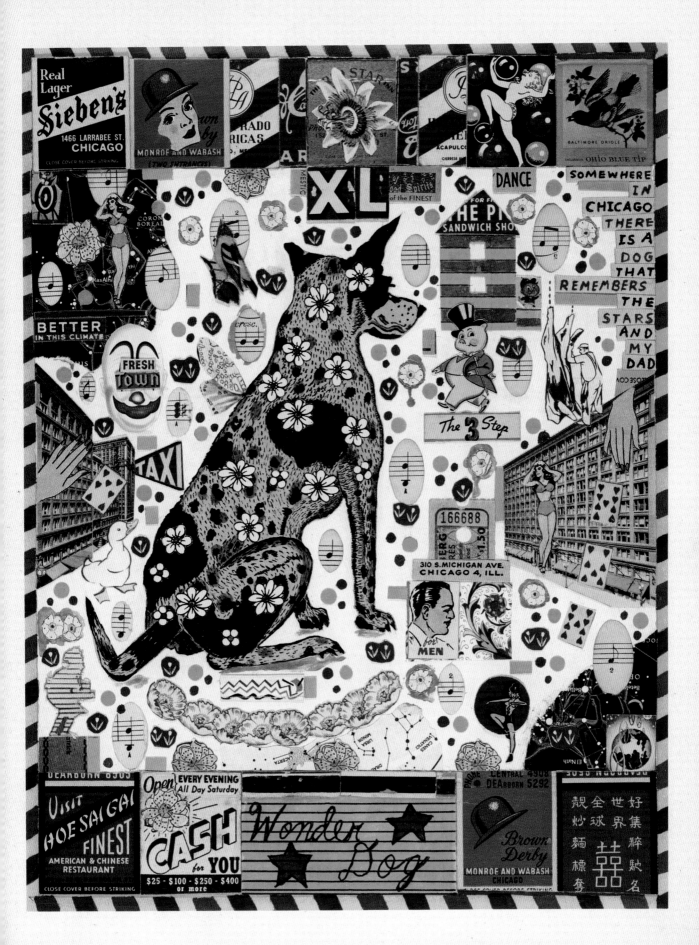

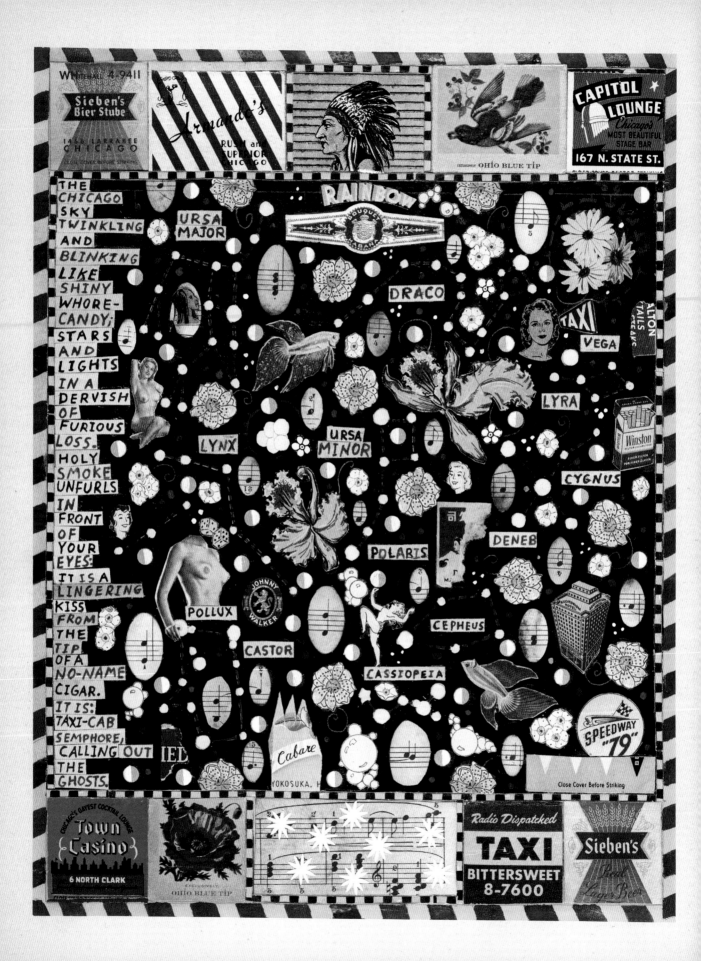

The Chicago Sky #1

2005 | 10" x 13"

Collection of Tim VanHouten

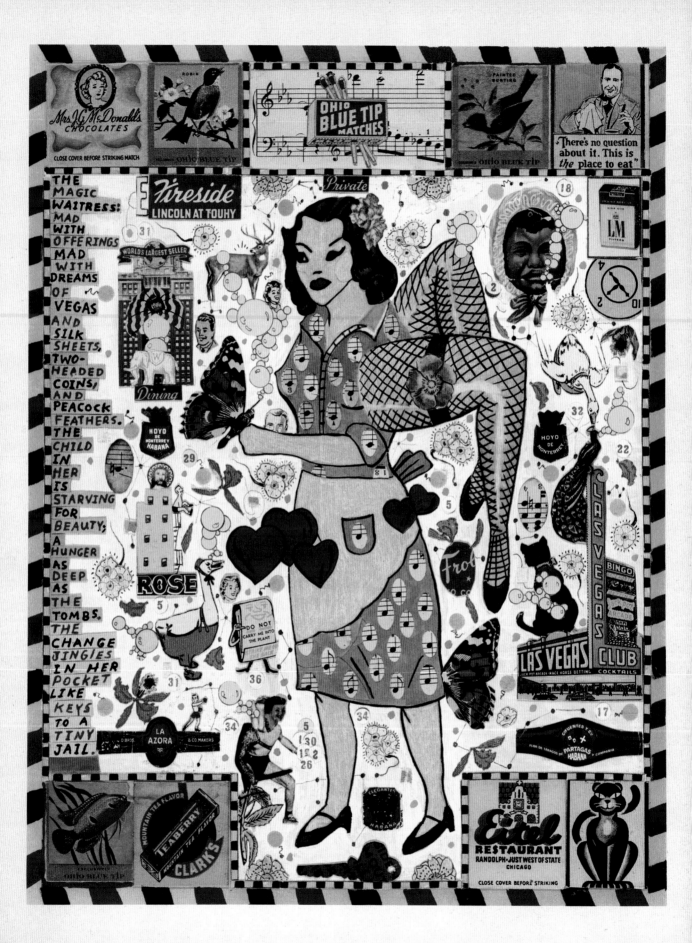

The Magic Waitress | 2005 | 10" x 13"

Collection of the Artist

Standing Beast | 2004 : 15 1/2" x 12"

Collection of Mickey Cartin

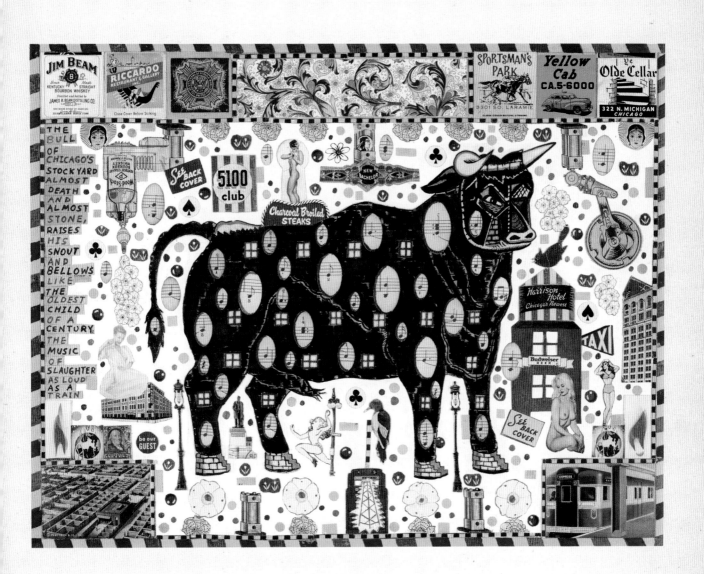

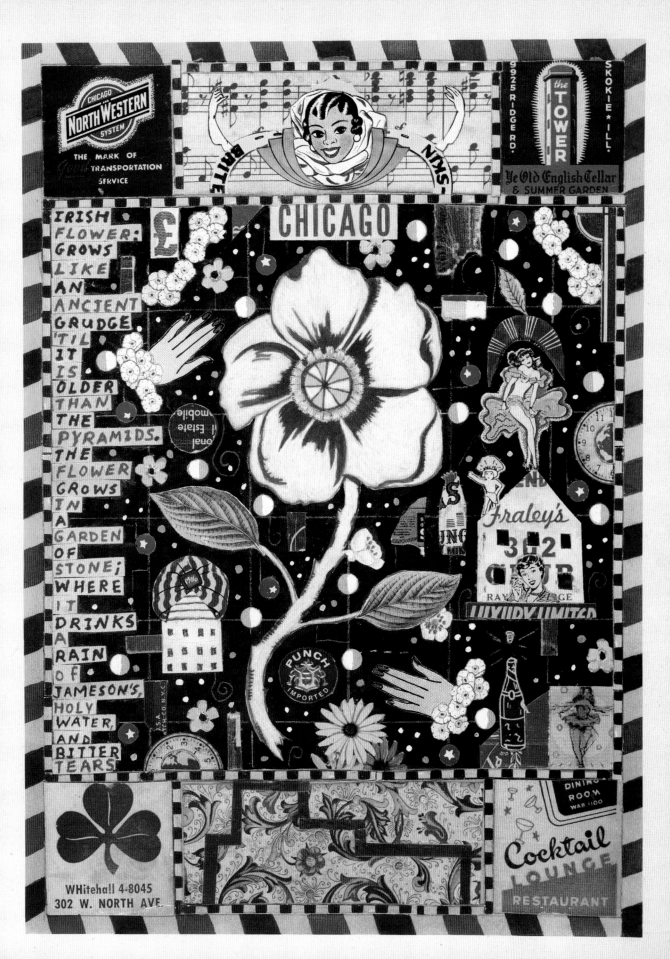

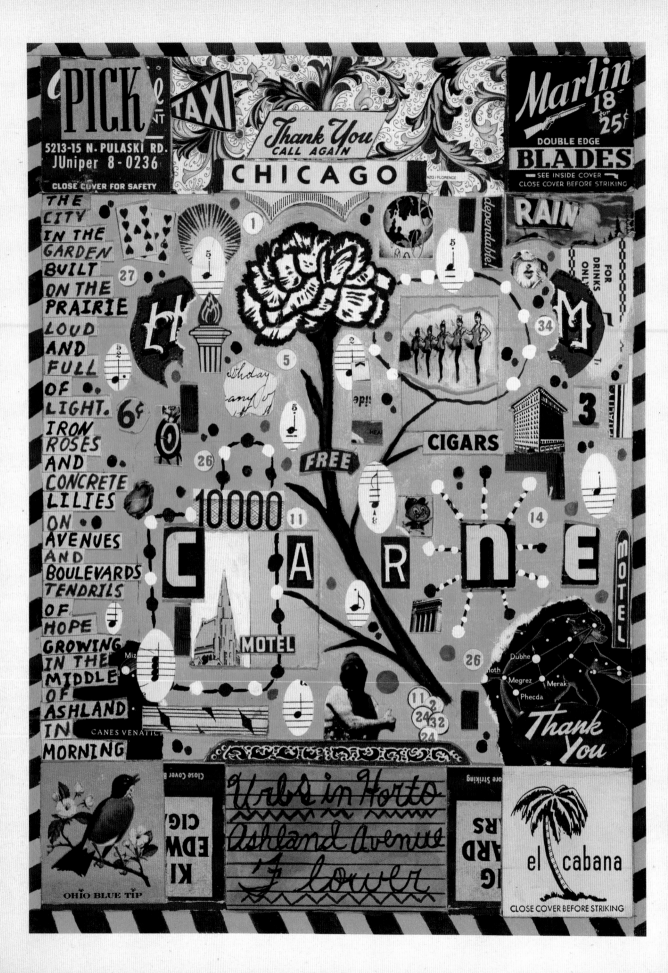

Ashland Avenue
Flower | 2004 : 10 1/2" x 7 1/2"
Collection of Amy Meehan

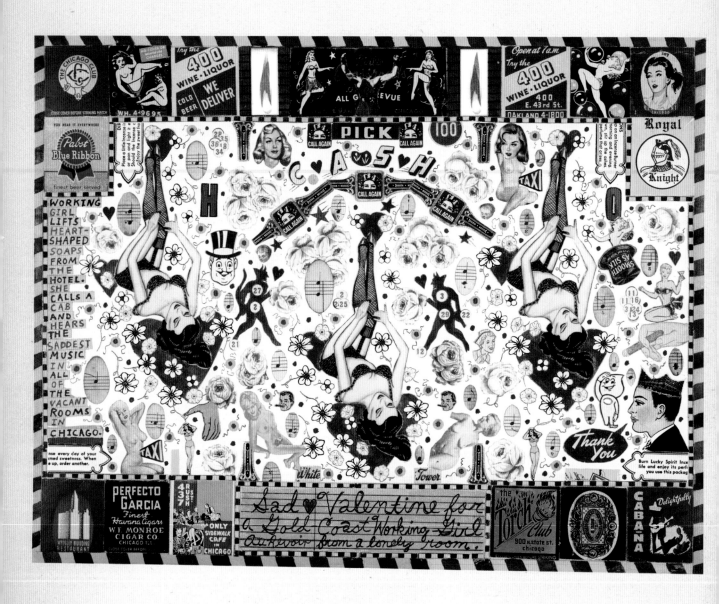

Sad ♥ Valentine for a Gold Coast Working Girl | 2005 | 15 1/2" x 12"

Collection of Hales Gallery, London

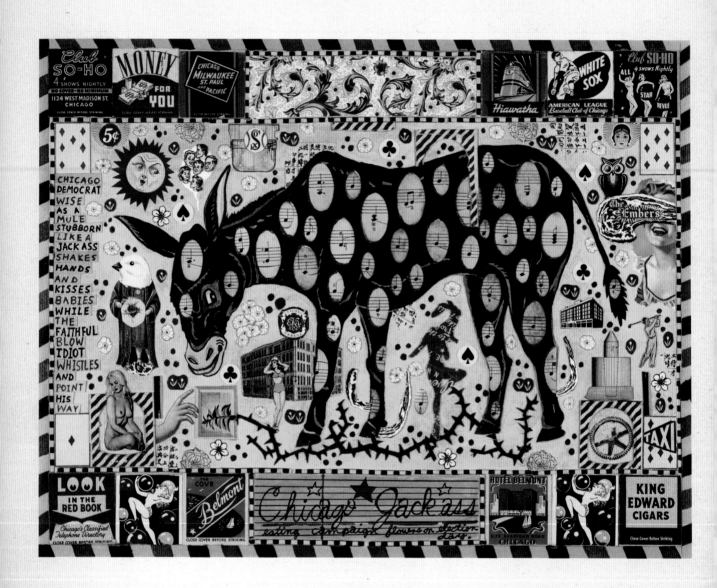

Chicago ☆ Jackass | 2004 ┊ 15 1/2" x 12"

Private Collection

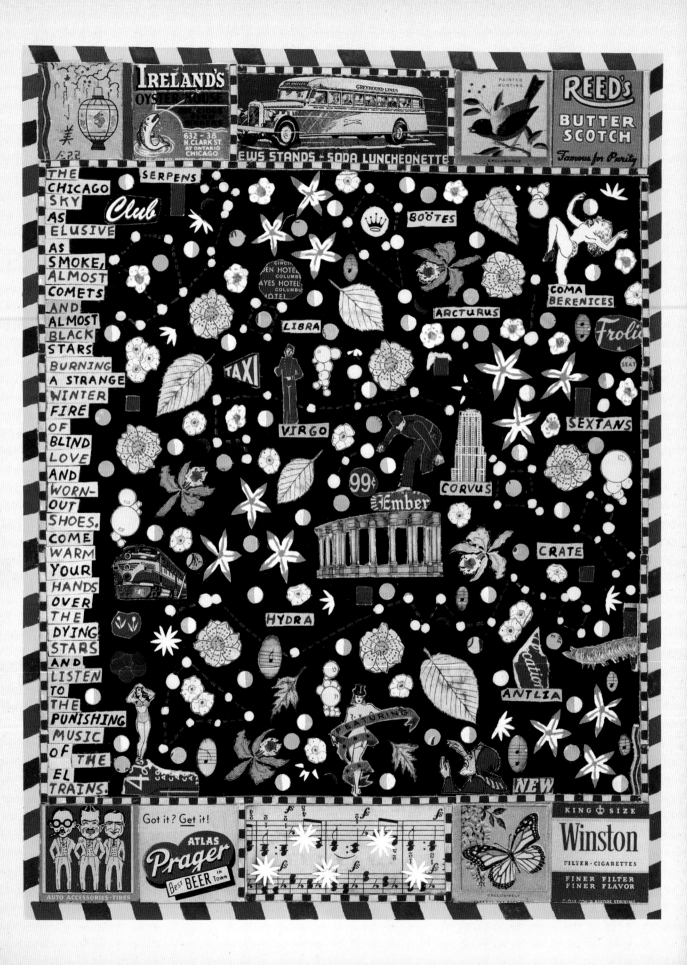

The Chicago Sky #2 | 2005 ⋮ 10" x 13"

Private Collection

Dog Years

2005 : 15 1/2" x 12"

Private Collection

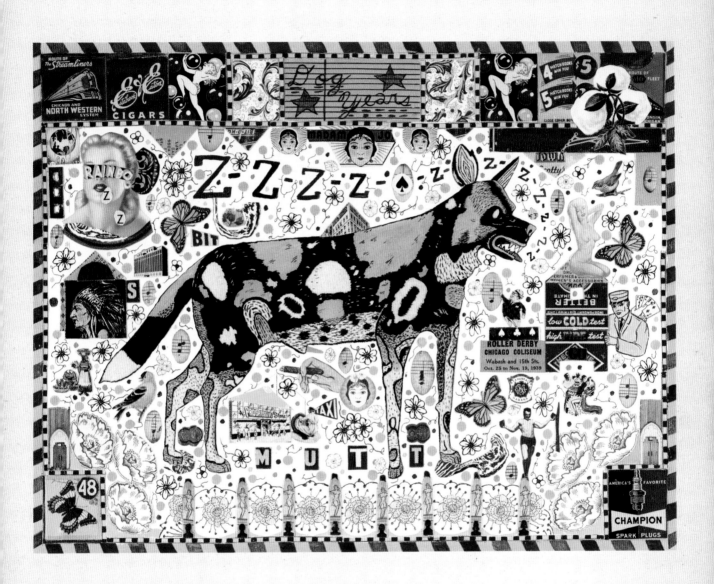

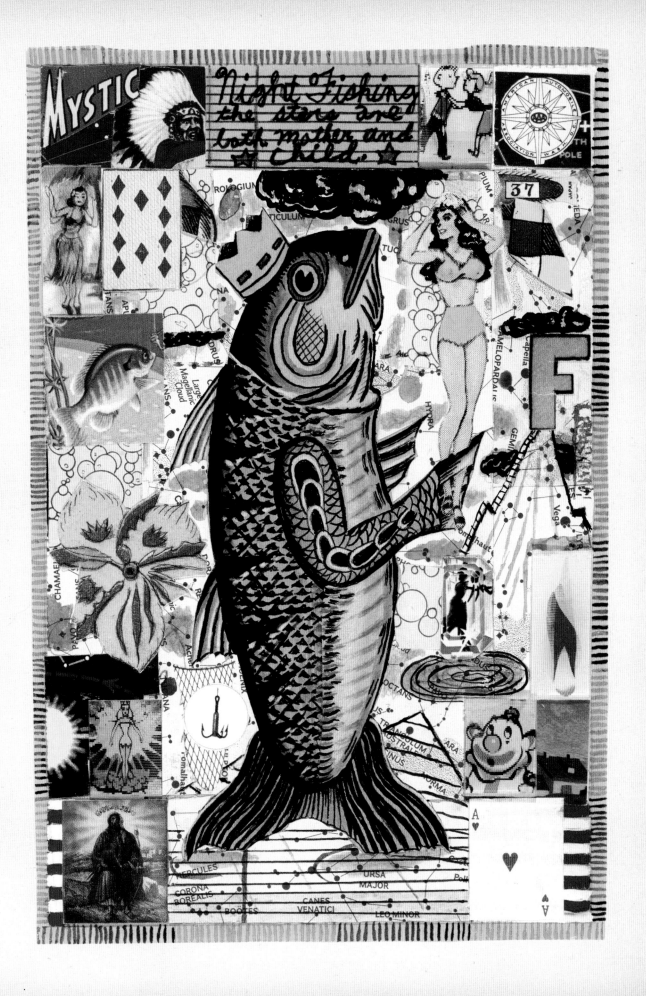

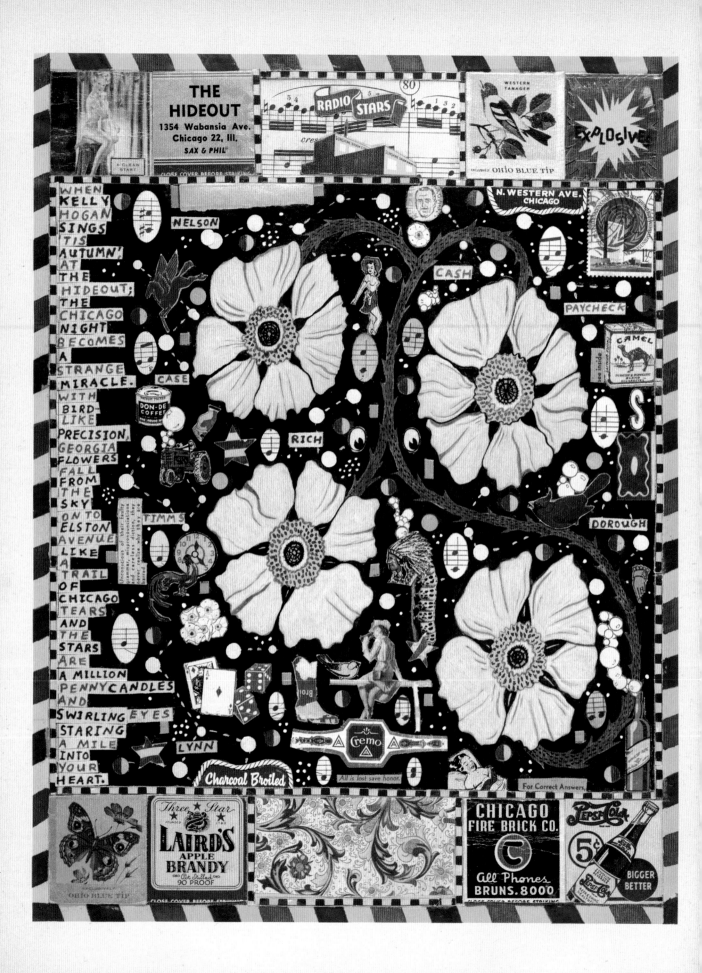

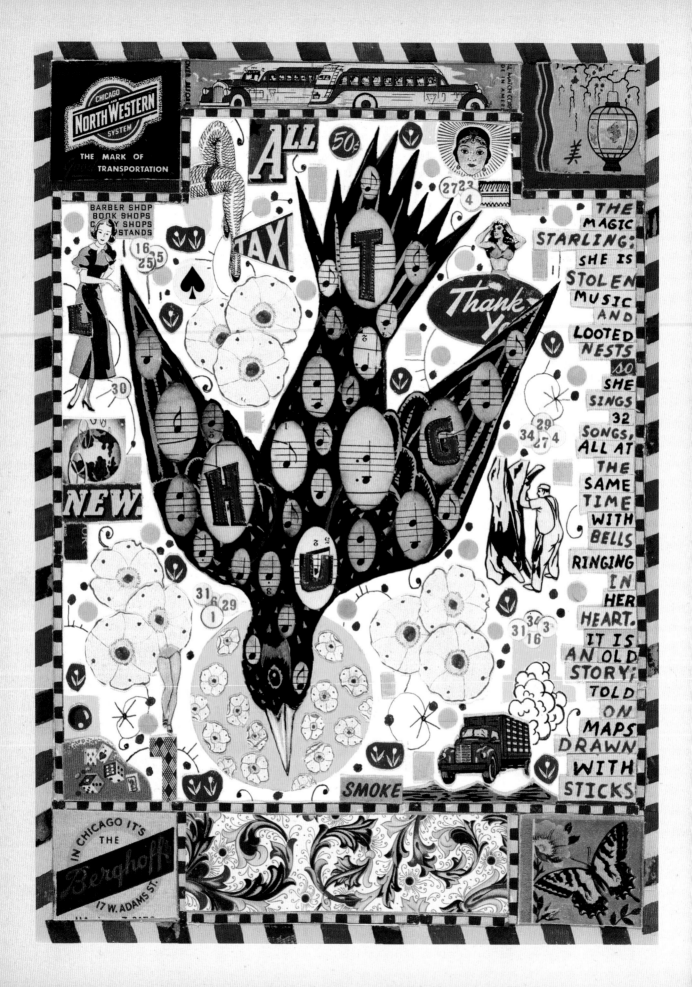

The Magic Starling 2004 ⋮ 7 1/2" x 10 1/2"

Collection of Billy Shire

The Girl Drug

Collection of Phil Wicklander

2005 10" x 13"

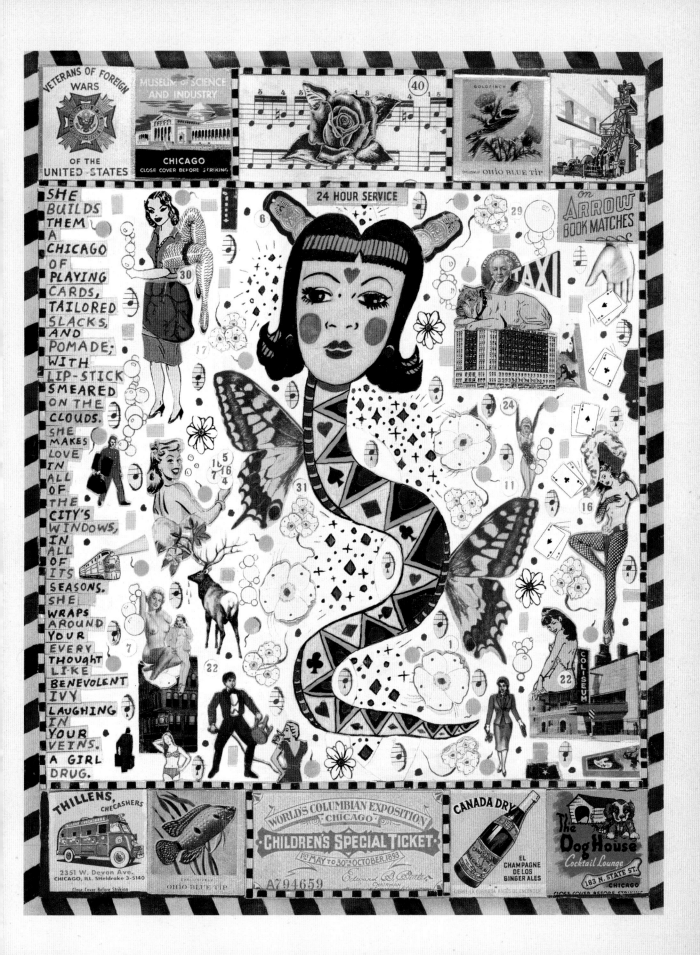

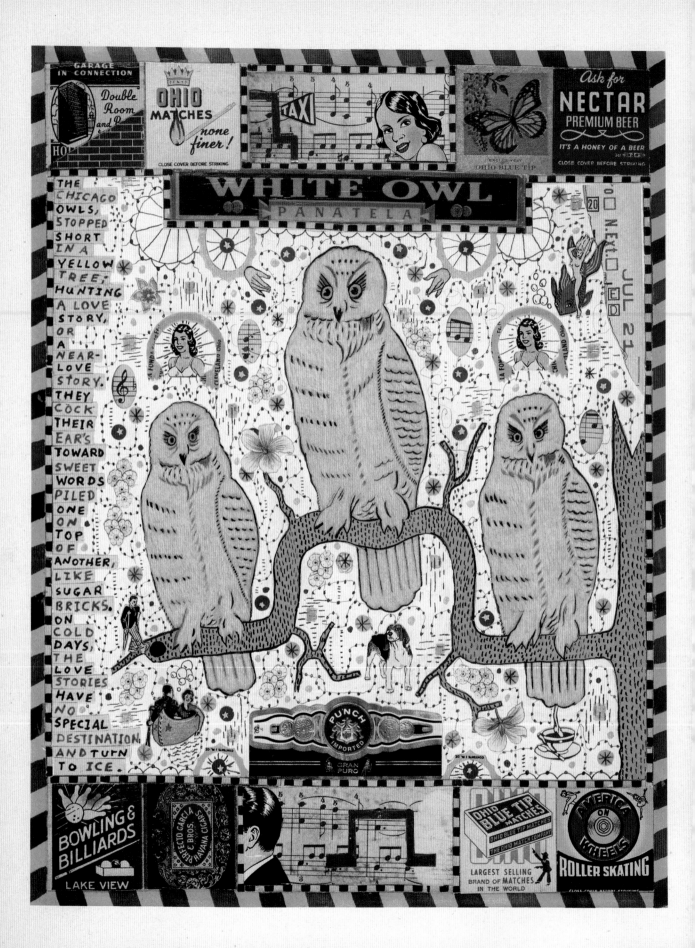

Chicago White Owls | 2005 | 10" x 13"

Collection of the Artist

Night ☆ ☆ Train

2004 10" x 13"

Collection of James Geier

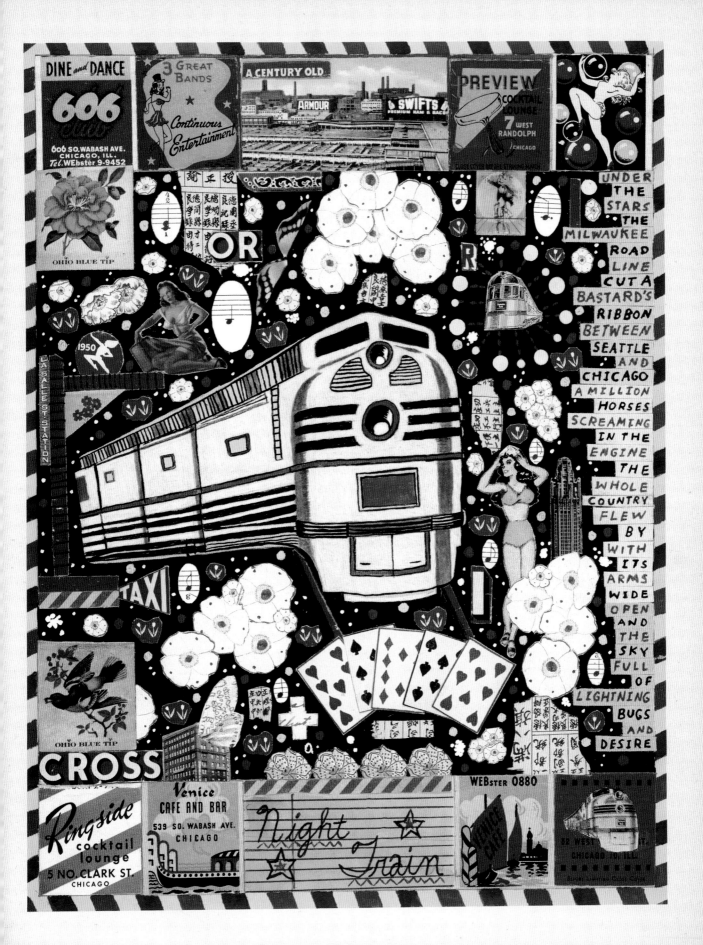

A South-side Rose | 2005 | 13" x 10"

Collection of Michelle Fire

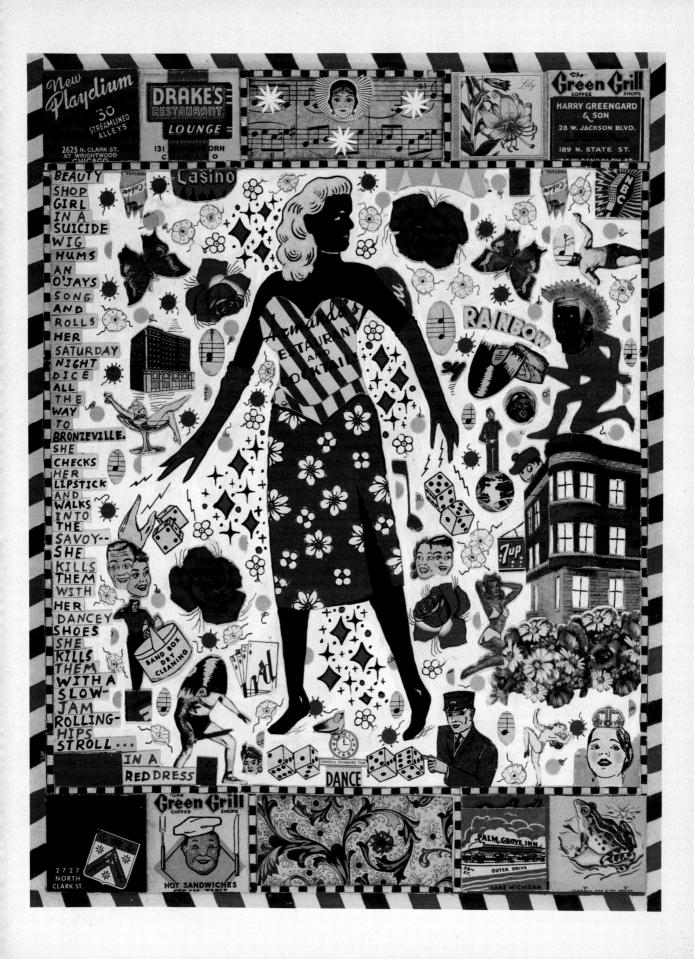

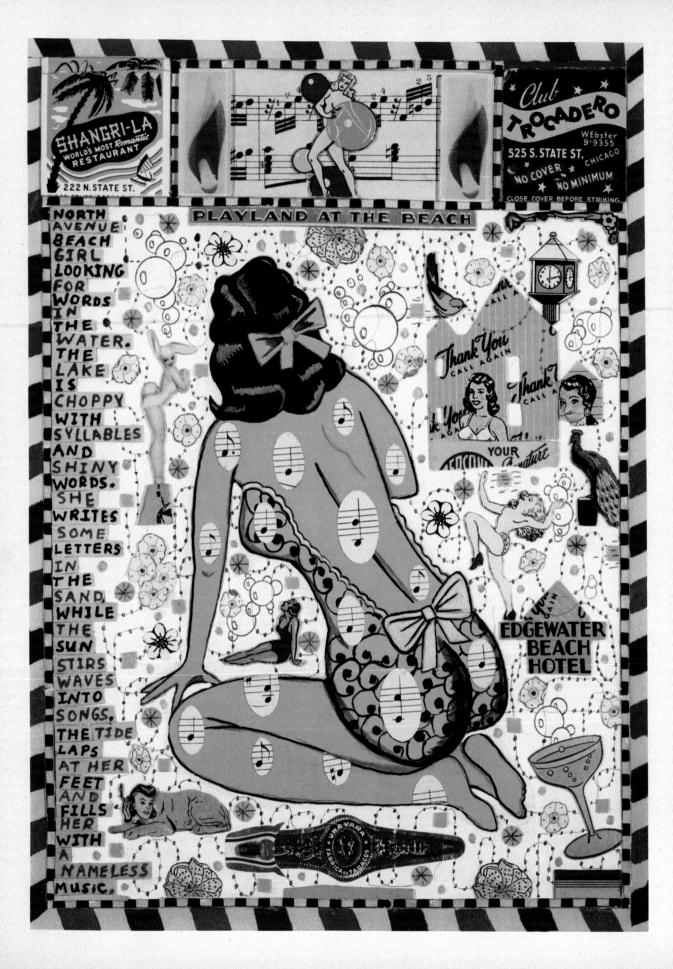

Woman at the Beach ♡ | 2005 | 7 1/2" x 10 1/2"

Collection of the artist

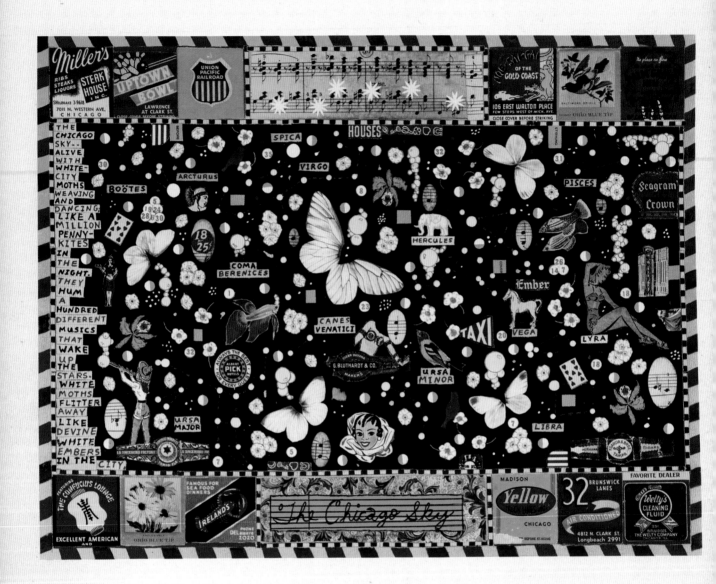

The Chicago Sky #3 | 2005 : 15 1/2" x 12"

Private Collection

Winter Spider

2005 | 10" x 13"

Private Collection

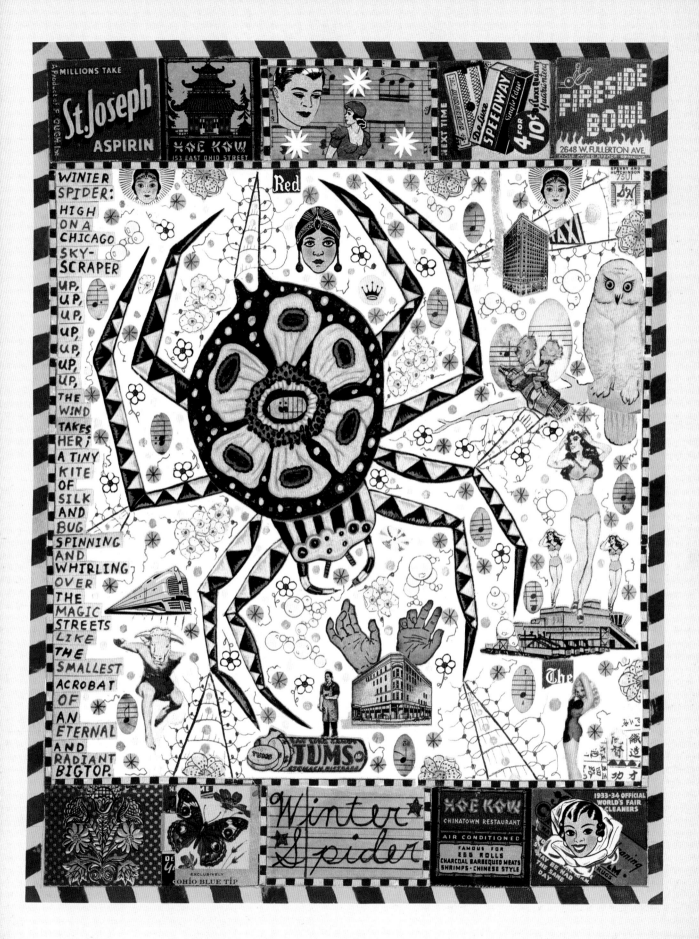

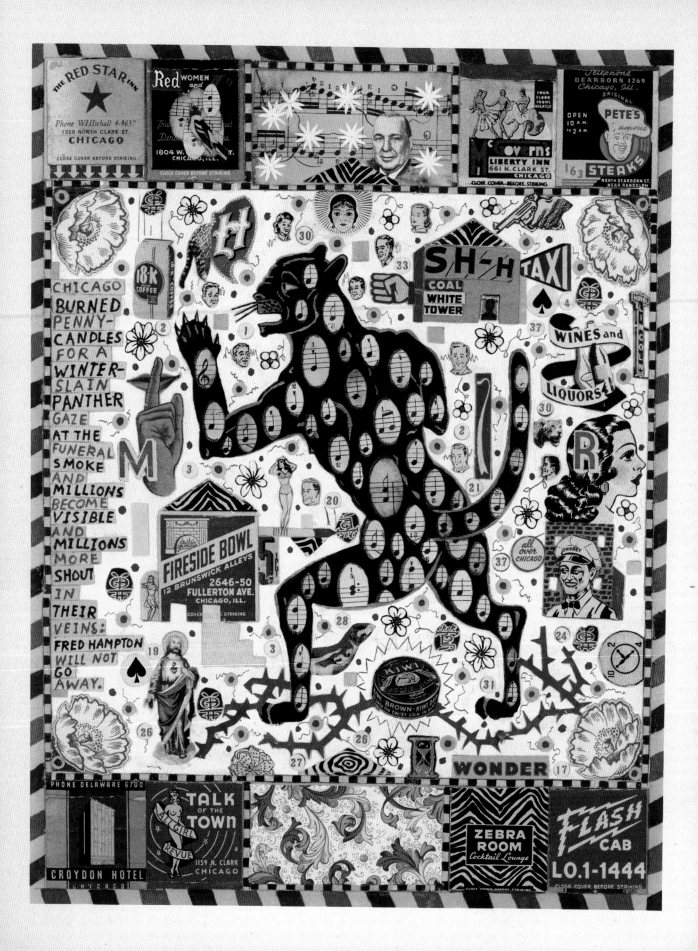

Blues for
Fred Hampton ☆ 2005 10" x 13"

Collection of Richard Massey

Chicago Beast

| 2005 | 7 1/2" x 10 1/2" |

Collection of the Artist

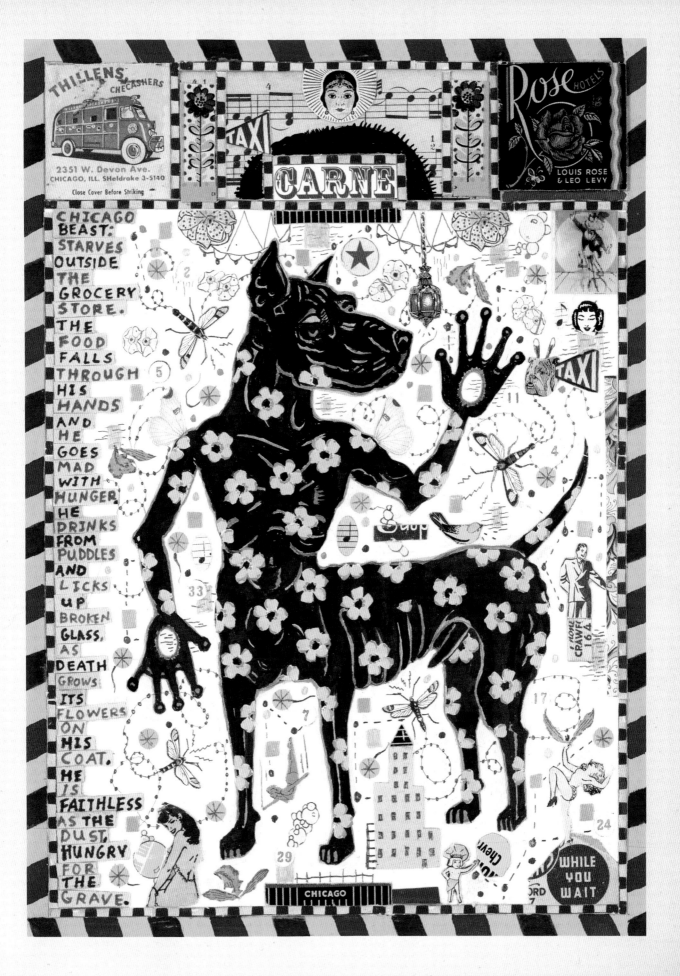

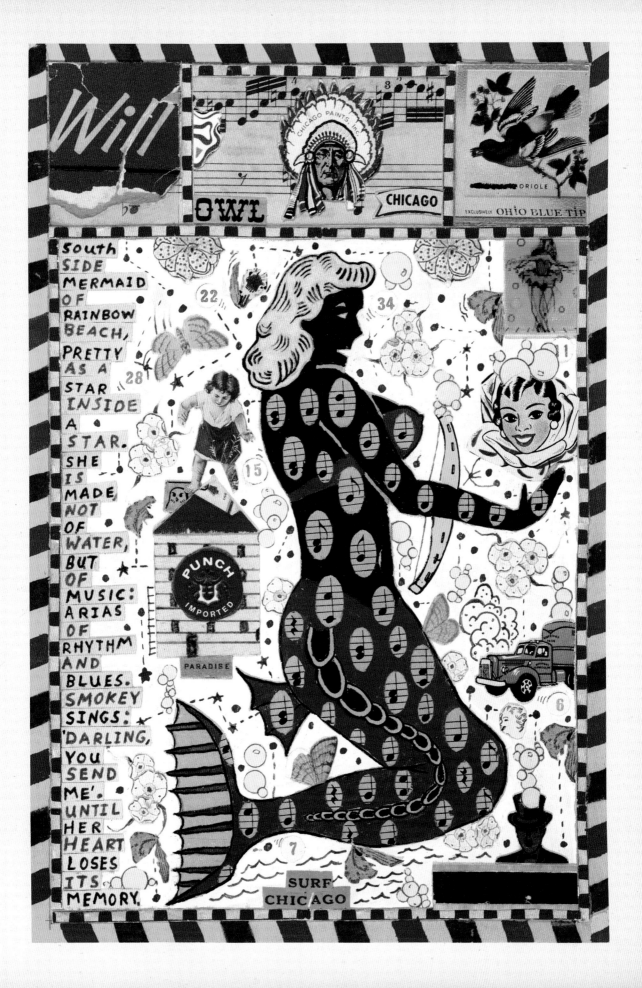

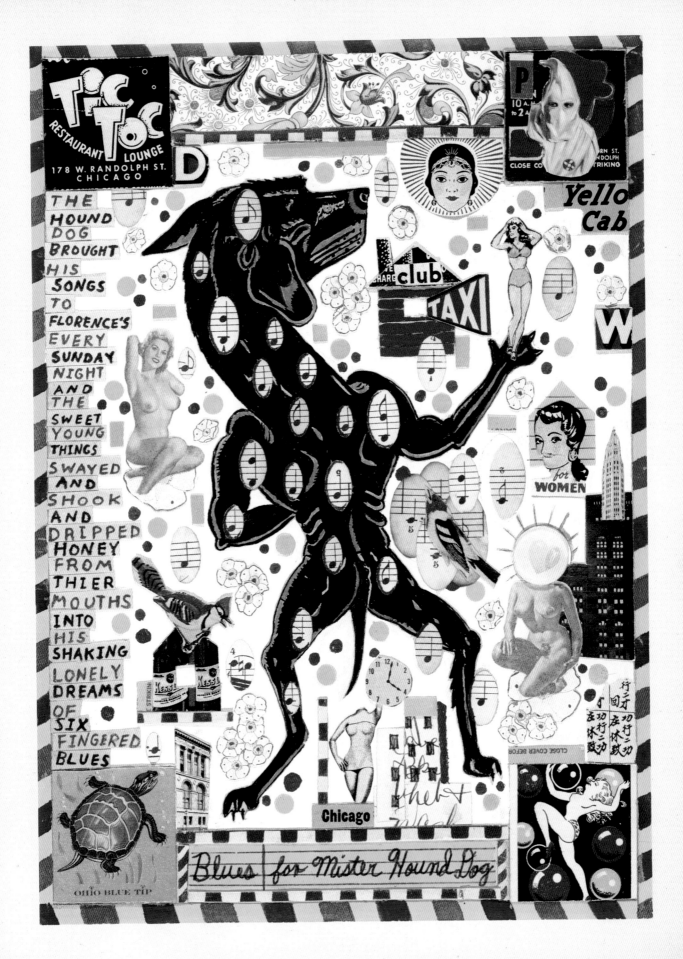

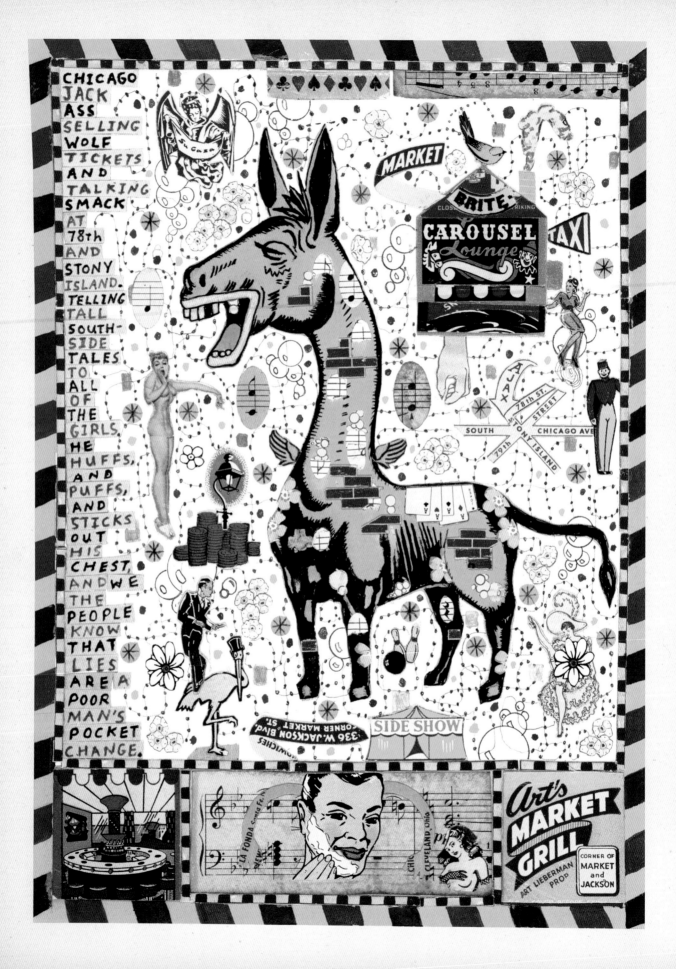

Yellow Jack Ass | 2005 : 7 1/2" x 10 1/2"

Private Collection

The Chicago Sky
#4

2005 ⋮ 12" x 15 1/2"

Collection of Mickey Cartin

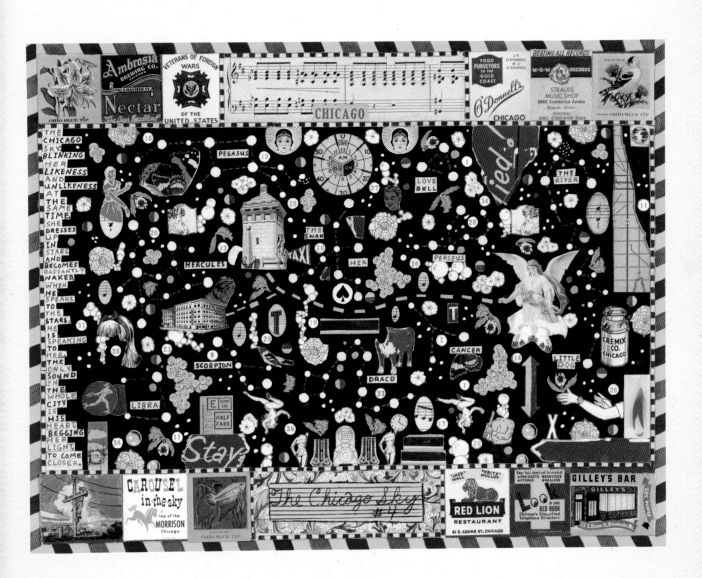

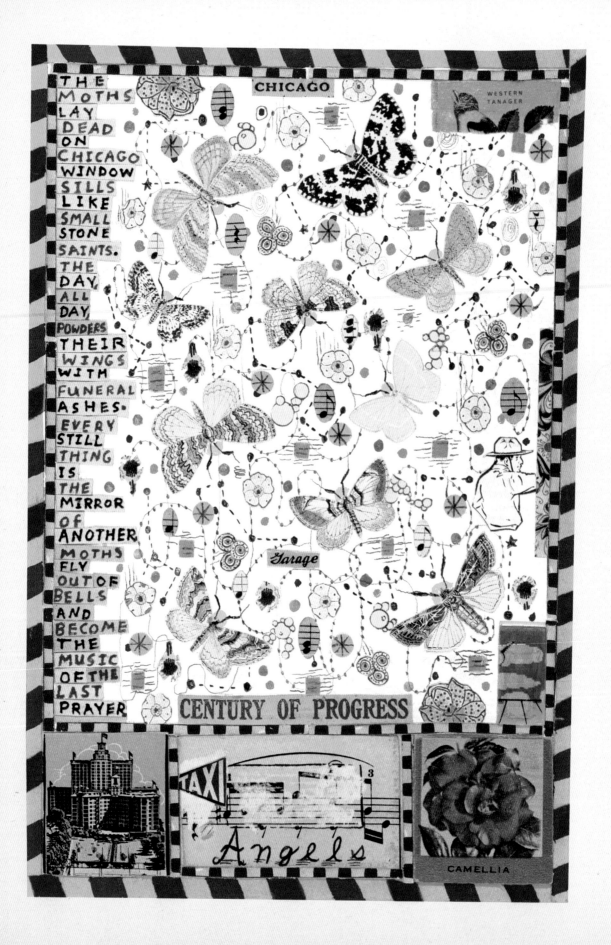

THE
MOTHS
LAY
DEAD
ON
CHICAGO
WINDOW
SILLS
LIKE
SMALL
STONE
SAINTS.
THE
DAY
ALL
DAY
POWDERS
THEIR
WINGS
WITH
FUNERAL
ASHES.
EVERY
STILL
THING
IS
THE
MIRROR
OF
ANOTHER
MOTHS
FLY
OUTOF
BELLS
AND
BECOME
THE
MUSIC
OFTHE
LAST
PRAYER

CHICAGO

WESTERN
TANAGER

Garage

CENTURY OF PROGRESS

TAXI

Angels

CAMELLIA

Angels | 2005 | 6" x 9"

Collection of the Artist

The Lonliest Chicago Republican 2005 15 1/2" x 12"

Collection of David Duckler

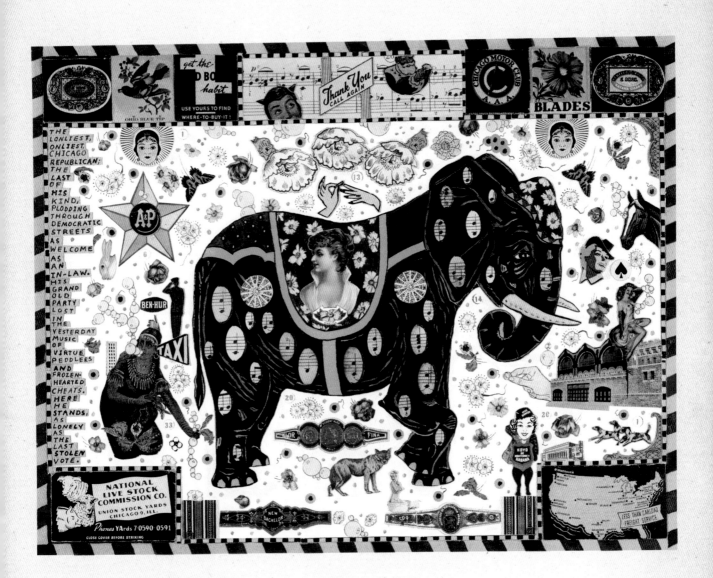

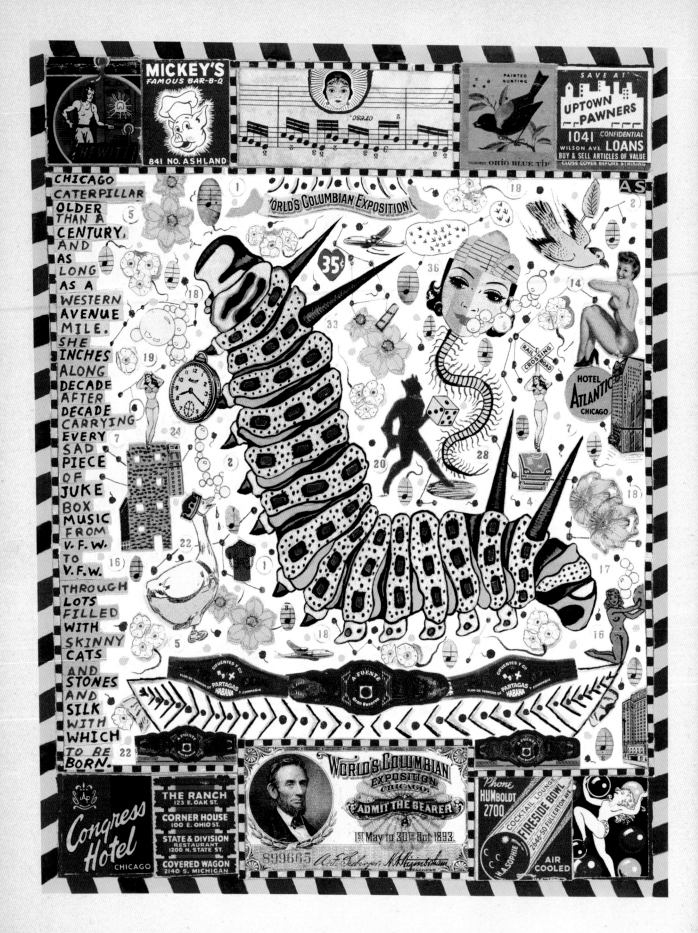

Chicago Caterpillar | 2005 | 10" x 13"

Collection of David Angelo

White Rose of Chicago | 2005 : 7 1/2" x 10 1/2"

Collection of the Artist

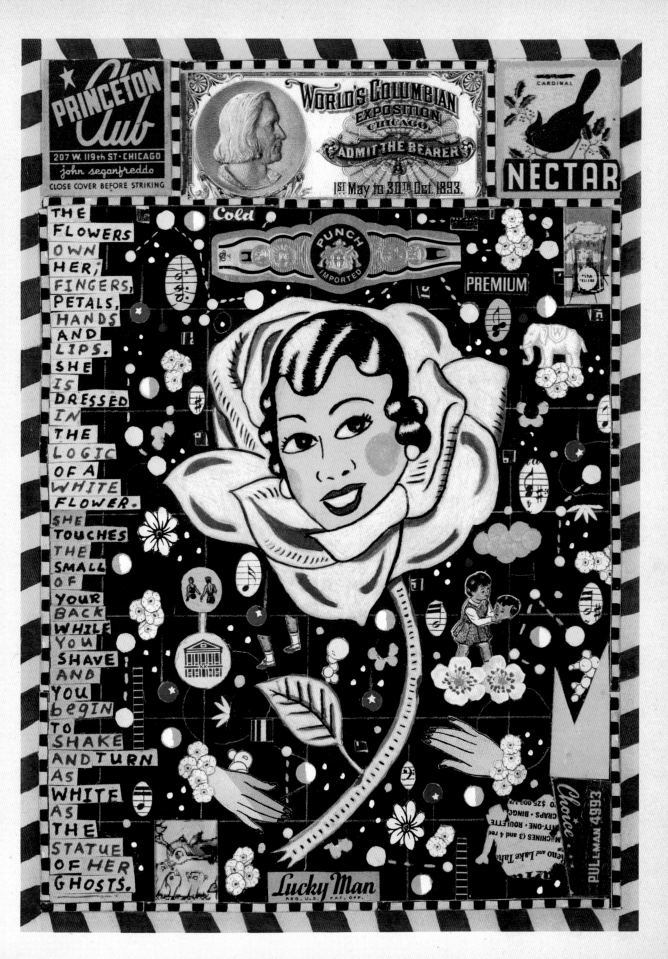

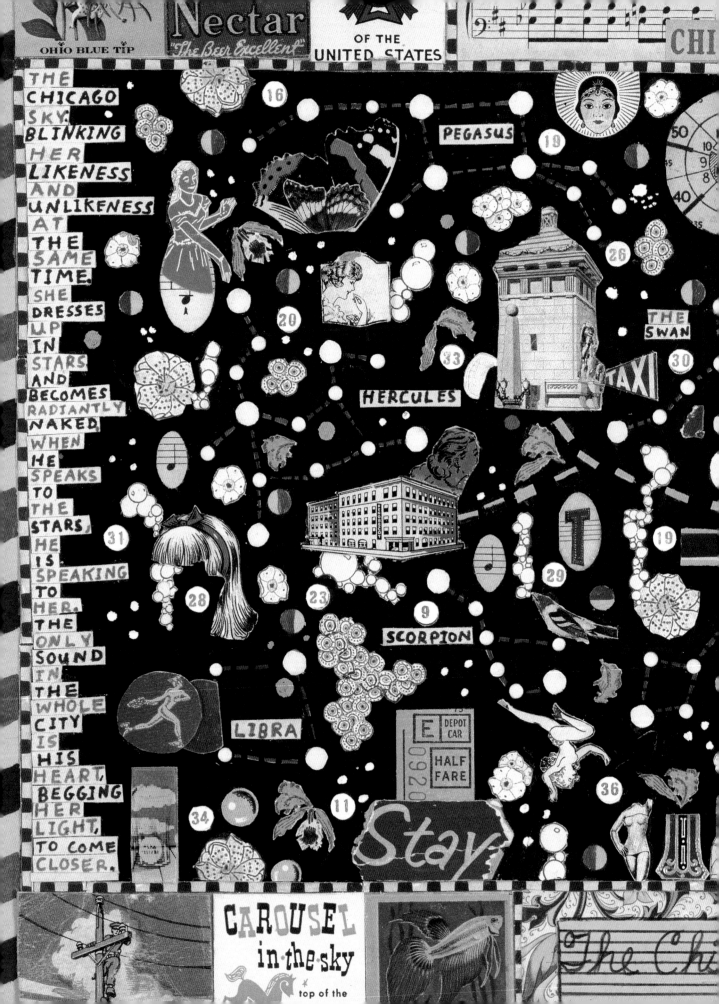

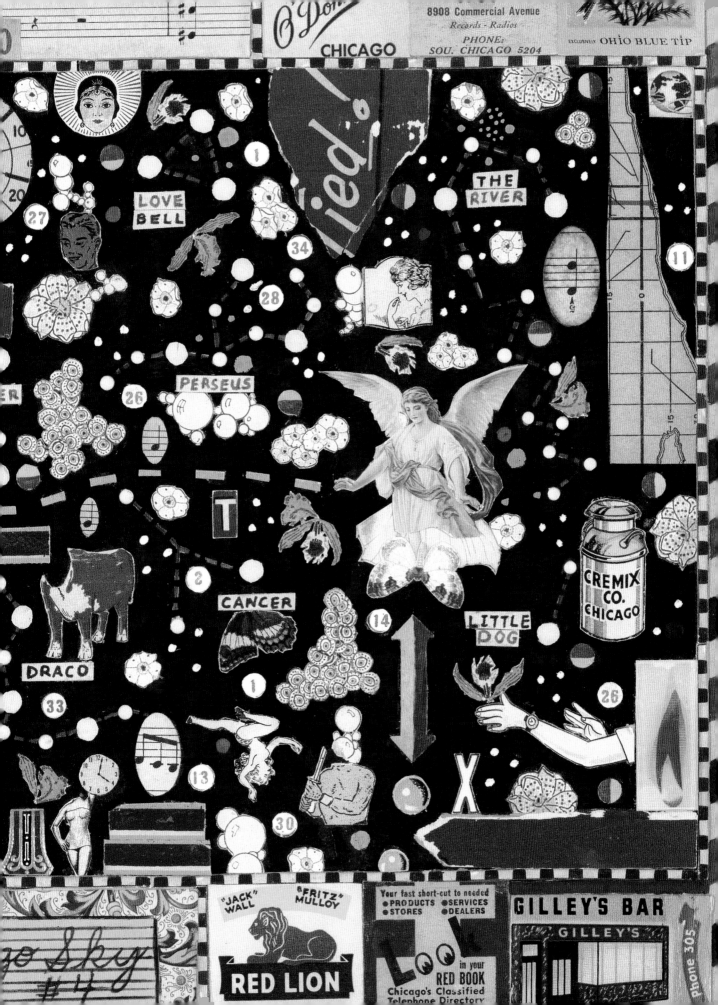

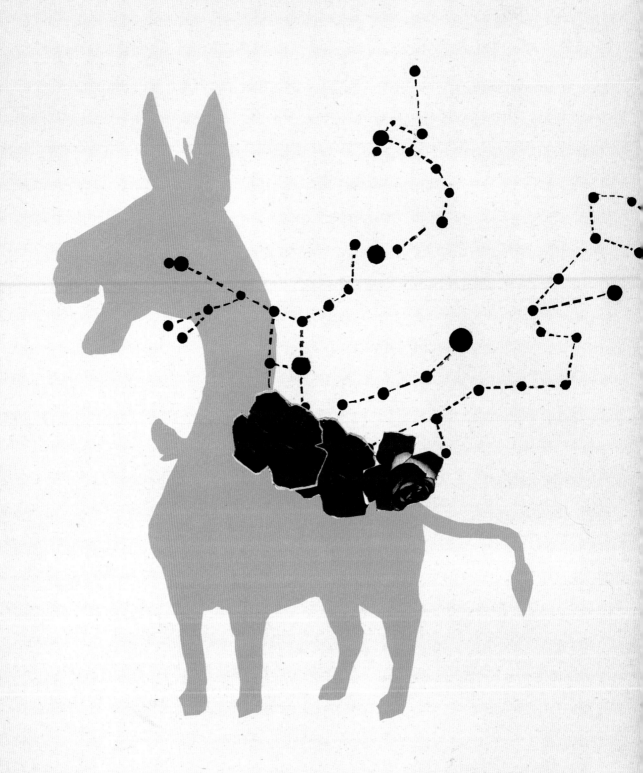

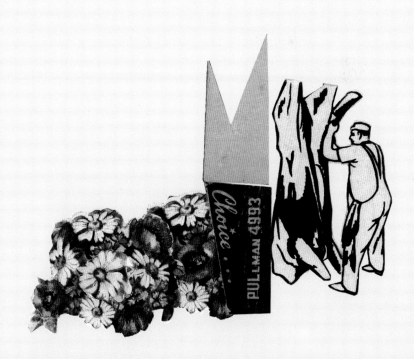

ACKNOWLEDGEMENTS

I'd like to thank my crew at Big Cat Press, where all of this work was made. They are: Adrienne Armstrong, Steve Griff, Josephine (Phiney!) Memije, Kate Richards and especially Michael Pajon.

Thank you to my friend Jim Callahan and his crew at MCM who do an amazing job framing this work– you guys are the best

Thank you Alex Kotlowitz for your love of Chicago and the wonderful essay.

Thank you: The 2005 World Champion Chicago White Sox, WXRT, Chicago Art Foundation, Hot Doug's, Bari Foods, Myopic Books, Quimby's, Suzy Takacs at the Book Cellar, Elizabeth Taylor, Michelle Fire, Ric Kogan, Kelly Hogan, Dave Hoekstra, Tim Anderson, Virginia Poundstone, Laura (Front Page) Eason, David Angelo, Paul Klein, Brice (Six Pack) Klein, Robbie Deveney, Andrew Rafacz, Keith Couser, Paul Hedge, Summer Guthery, Tony Judge, Teddy Varndell, Tommy Kieft, David Duckler, Mary-Jo Mostowy, Fred Tomaselli and Laura Miler, Ross Deutsch, John Anderson, The Lovely Nelson sisters, Joe Coleman, Wes Mills, Penn Jillette, Lou Reed, Bari Zaki, Beth Barnett, Ken Brown, Bill Fitzgerald, Colin Summers, Nell Scovell, Michael Tropea, Bob and Barbara Stone, Danielle Tegeder, Thom VanHorn, Joe Shanahan, Hillel Levin, Bruce Springsteen, Diane Villani, Mary Houlihan, Bob O'Connell, Jonathan Demme, John McNaughton, John Rice, Sharon and Michael Rivas, Drew and Michelle Jahelka, Marc Hauser, Julie Parson-Nesbitt, Stefanie Kohn, Ann and Walter Nathan, Craig Johnson, Katie Rashid, Kat Parker, Hugh and Robin Breslin, Kevin Charnota, Heiji Choy, Dan Ferrara, Reg Gibbons and Marc Turcotte, Studs Terkel, Buzz Kilman, Jack 'Red' Hogan and his son, le chef, the great John 'Duke' Hogan, Glenn Keefer and Rich Keefer.

Thank you Carie Lovstad for all of your support and friendship.

Thank you Cliff Diver for your friendship and hospitality.

Thank you Jon-boy Langford, world's greatest limey.

Thank you Shupesy.

Thank you to my amazing landlord and friend Walter Aque.

Thank you Billy Shire for making this happen.

Thank you Mickey Cartin – you are the emmis.

Thank you Nick Bubash – partner in crime

Thank you Joe Amrhein and Susan Swenson of Pierogi Gallery in Brooklyn for ending my losing streak.

A very special Thank You to Ted Frankel– Uncle Fun– for his help in finding scraps, winkies, and naked lady stuff–
I owe you big-time Mr. Fun.

Thank you Bill Savage whose editing prowess has not been affected by the fact that he is a Cubs fan.

Thank you Dawn Hancock and the Firebelly Design crew—
Travis Barteaux, Kara Brugman, Antonio Garcia, Nako Okubo,
Aaron Shimer—for their love and dedication. It shows on every page.

Thank you Steve Earle and Allison Moorer.

Thank you Michele, Max and Gaby.

Thank you Mom.

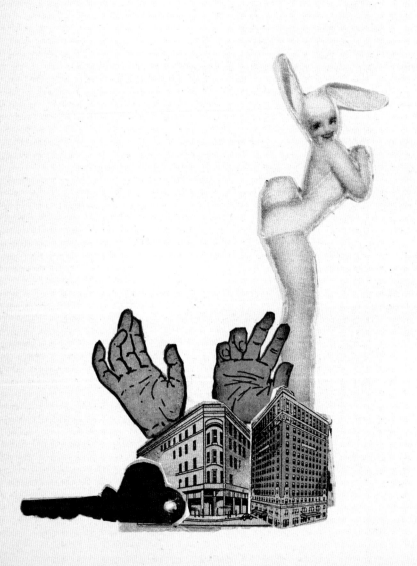

Photo by Hayley Murphy

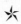

Tony Fitzpatrick, author of *The Wonder: Portraits of a Remembered City, Volume 1* and published poet, was born in Chicago in 1958. He lives there now with his family.

THE
MOTHS
LAY
DEAD
ON
CHICAGO
WINDOW
SILLS
LIKE
SMALL
STONE
SAINTS.
THE
DAY,
ALL
DAY,
POWDERS
THEIR
WINGS
WITH
FUNERAL
ASHES.
EVERY
STILL
THING
IS
THE
MIRROR
OF
ANOTHER
MOTHS
FLY
OUT OF
BELLS
AND
BECOME
THE
MUSIC
OF THE
LAST
PRAYER

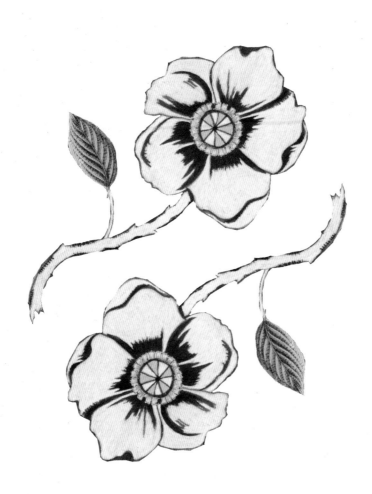